Eye

GLI OCCHIALI

Franca Acerenza

CHRONICLE BOOKS

SAN FRANCISCO

First published in the United States of America by Chronicle Books in 1997.
Copyright © 1988 by BE-MA Editrice.

Printed in Hong Kong.

Library of Congress Cataloging-in-Publication Data:
Acerenza, Franca.
 Eyewear = Gli Occhiali/Franca Acerenza,
 p. cm —/ (Bella cosa)
 Previously published: Gli occhiali.
 Includes bibliographical references (p.).
 ISBN 0-8118-1870-5 (pb)
 1. Eyeglasses—History. 2. Eyeglasses—Pictorial works.
 I. Acerenza, Franca. Gli occhiali. II. Title.
 III. Series.
 GT2370.A27 1997
 391.4'4—dc21 96-50007
 CIP

Photography: Edoardo Chierici
Series design: Dana Shields, CKS Partners, Inc.
Design/Production: Robin Whiteside

Distributed in Canada by Raincoast Books
8680 Cambie Street
Vancouver, B.C. V6P 6M9

10 9 8 7 6 5 4 3 2 1

Chronicle Books
85 Second Street
San Francisco, California 94105

Web Site: www.chronbooks.com

Introduction

The early creation of spectacles in Italy can be attributed to the master-glassmakers of Venice, who toward the end of the thirteenth century developed ways to shape glass to alleviate deficiencies of sight.

This book of color photographs, based on a fine collection in Italy, illustrates the diverse shapes, technical devices, and materials used in frames for spectacles, presenting pieces that best exemplify the different countries of origin and successive historical periods. Thus the history of this small but important invention is told from early bow eyeglasses and types worn with powdered wigs to the sunglasses designed by Christian Dior.

These objects are an expression of history and of the struggle to preserve a precious gift: sight.

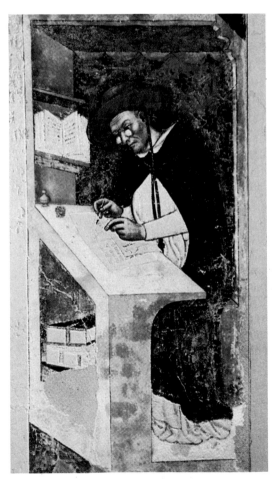

Tomaso da Modena
Cardinal Hugh of Provence in his study. Fresco (1352), Church
of San Nicolò, Treviso, Italy.

Tomaso da Modena
Il Cardinale Ugo da Provenza nello studiolo. Affresco (1352),
Treviso, S. Nicolò.

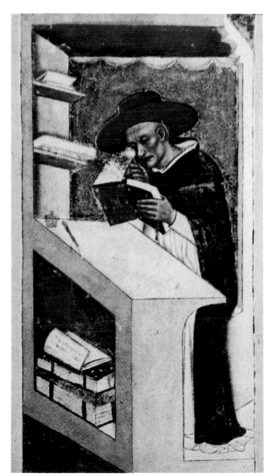

19th-century copy of 15th-century horn
spectacles with hinged frame.

*Copia ottocentesca di occhiale in corno con
montatura a perno del secolo XV.*

18th-century copy of late 15th-century wood-
framed spectacles.

*Copia ottocentesca di occhiale in legno della
fine del sec. XV.*

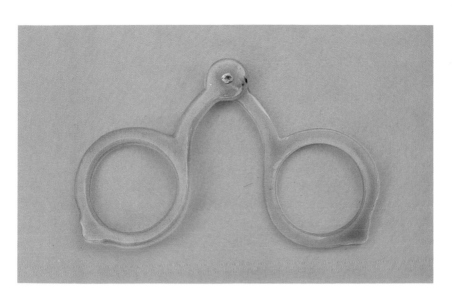

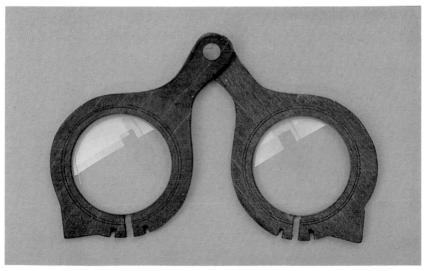

18th-century copy of 15th-century iron-framed spectacles.

Copia ottocentesca di occhiale in ferro del sec. XV.

18th-century copy of leather-framed spectacles, typical of the 15th century.

Copia ottocentesca di occhiale in cuoio in uso nel sec. XV.

18th-century copy of 17th-century horn-rimmed spectacles.

Copia ottocentesca di occhiale in corno del sec. XVII.

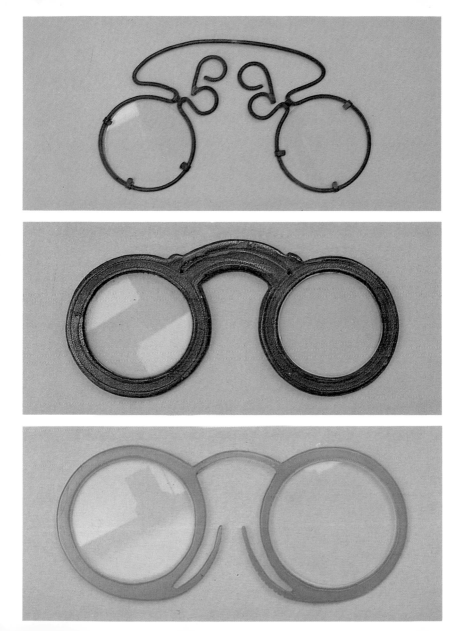

The prophet Habakkuk
Fresco in the church of St. Maria and St. Siro at Sale (near
Alessandria), Italy, circa 1456. (By kind permission of Cariplo.)

Profeta Abacuc
Affresco nella Chiesa di Santa Maria e San Siro a Sale (AL), 1456 c.
(Per gentile concessione della Cariplo.)

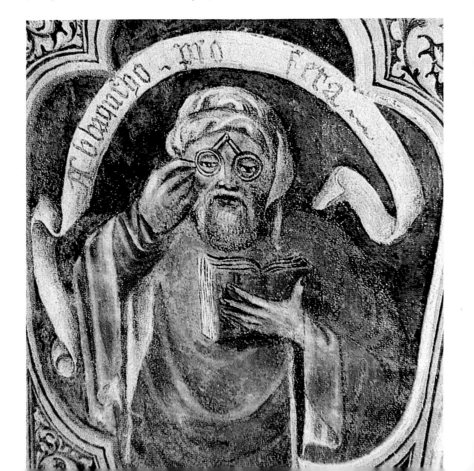

\mathcal{B}ow spectacles made of baleen (the horny plates from the mouths of certain whales, used to filter plankton). Baleen was procured from the North Sea, where Basque, Dutch, French, and English whalers worked, and was used for spectacles from 1500 to 1700.

Occhiali ad arco in fanone (lamina cornea di cui sono dotate le balene per filtrare il plancton). Il materiale proveniva dai mari del nord dove operavano attivamente balenieri baschi, olandesi, francesi e inglesi. Questro materiale fu utilizzato dal 1500 al 1700.

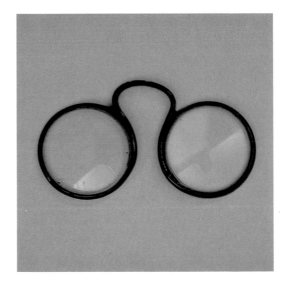

*H*inged bow spectacles with central pivot. Italian, 17th century. One of the oldest types of frames.

Occhiali ad arco brisé con perno centrale. Manifattura italiana sec. XVII. Questo tipo di occhiale rappresenta una delle forme più antiche di montatura.

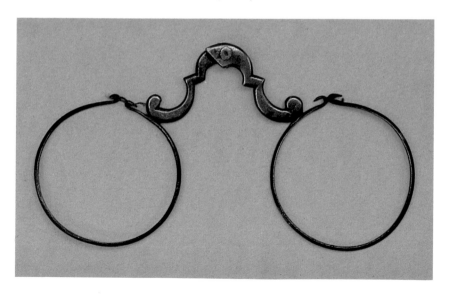

\mathcal{F}lat spectacle case in boxwood. The spring-fitted lid is opened by pushing a wrought-iron hinge on the back of the case. Made in northern Europe, 17th century.

Astuccio per occhiali a tasca orizzontale in legno di bosso. Il coperchio si apre mediante un meccanismo a molla azionato spingendo un perno, di ferro battuto, posto nella faccia posteriore. Manifattura nordeuropea, sec. XVII.

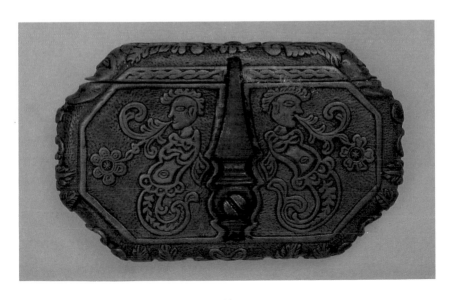

\mathcal{B}ook-form case of inlaid wood, containing two pairs of bow spectacles. The outer faces of the case are decorated with two medallions, relief-carved in the same way as a cameo, showing a pair of profile busts. Probably made in Italy during the 18th century.

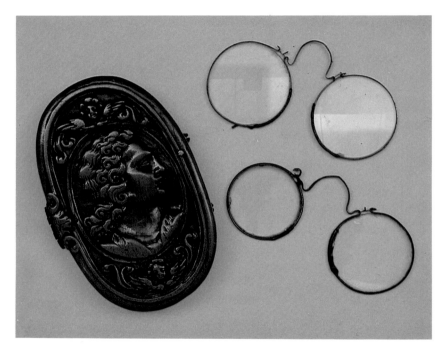

Astuccio a libro in legno intarsiato contenente due paia di occhiali ad arco. Le facce esterne dell'astuccio sono decorate da due medaglioni intagliati a bassorilievo tipo cammeo rappresentanti due mezzi busti di profilo. Probabilmente manifattura italiana, sec. XVIII.

\mathcal{G}omar Wouters after Cornelius Meyer (1689). Spectacles for all types of sight. Engraving, 17.5 x 23.1 cm.

Wouters, Gomar da Cornelius Meyer (1689). Occhiali per tutte sorti di viste. Incisione, cm. 17.5 x 23.1.

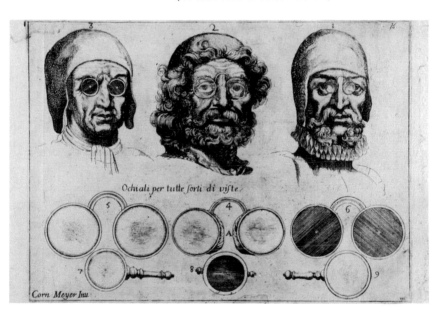

\mathcal{B}oxwood case containing two pairs of bow spectacles in copper wire. Second half of the 18th century.

Astuccio in legno di bosso contenente due paia di occhiali ad arco in rame trafilato. Seconda metà del sec. XVIII.

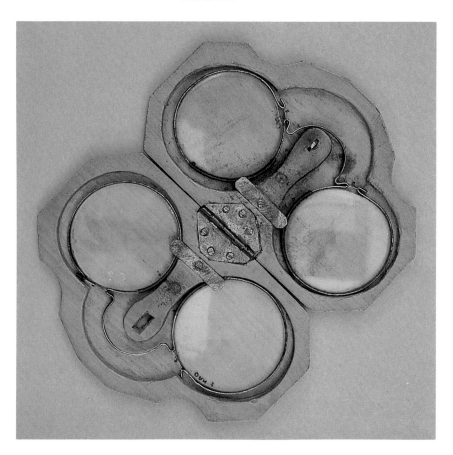

\mathcal{F}lat case in boxwood briar, with a pair of copper wire bow spectacles. The arch has a double curve, and the rims are padded with green silk on the inner side to make the spectacles more comfortable. Italian, early 18th century.

Astuccio a tasca orizzontale in radica di bosso con occhiali ad arco in rame trafilato. L'arco presenta doppia curvatura con imbottitura in seta verde all'interno delle cerchiature per rendere meno molesto l'occhiale. Manifattura italiana inizi sec. XVIII.

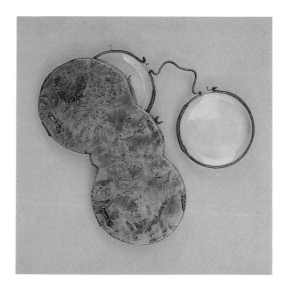

Bow spectacles with flat case in briar.
Italian, second half of the 18th century.

Occhiale ad arco con astuccio a tasca in radica.
Manifattura italiana, seconda metà del sec. XVIII.

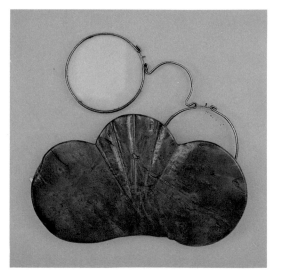

\mathscr{L}eather envelope for four pairs of spectacles, containing two bow spectacles made in copper wire. The pairs are of different dioptric strengths and are marked "London." 18th century.

Astuccio a busta quadriposto in pelle contenente due paia di occhiali ad arco in rame trafilato. Gli occhiali sono di diverse diottrie e presentano la sigla: London. Sec. XVIII.

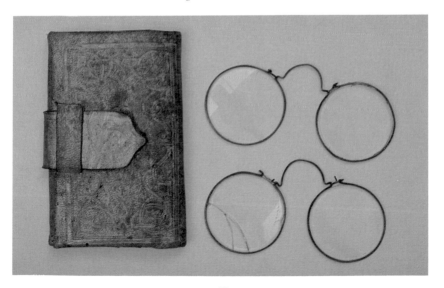

\mathcal{F}lat case with bow spectacles. The wooden case is inscribed "1792," though certain features could suggest an earlier date.

Astuccio a tasca orizzontale con occhiali ad arco. L'astuccio è in legno con incisa la data 1792 anche se per le caratteristiche di lavorazione potrebbe appartenere ad epoca precedente.

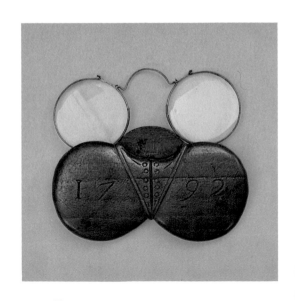

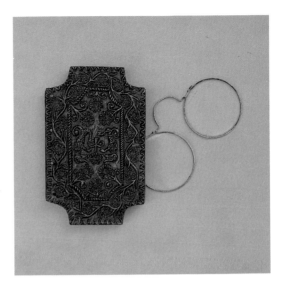

Casket-case of inlaid rose-wood with bow spectacles. Middle Eastern, 18th century.

Astuccio a scrigno in palissandro intarsiato con occhiali ad arco. Manifattura medio-orientale. Sec. XVIII.

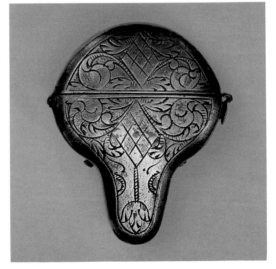

Engraved bronze case for two pairs of bow spectacles with central hinge. 18th century.

Astuccio in bronzo inciso per un paio di occhiali ad arco con perno centrale. Sec. XVIII.

\mathcal{L}eather and cardboard case containing bow spectacles. Italian, 18th century.

Astuccio in cartone e pelle contenente occhiali ad arco. Manifattura italiana, sec. XVIII.

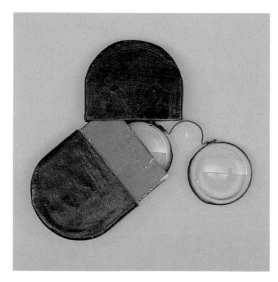

\mathcal{E}ngraved bronze case for two pairs of bow spectacles with central hinge. 18th century.

Astuccio in bronzo inciso per un paio di occhiali ad arco con perno centrale. Sec. XVIII.

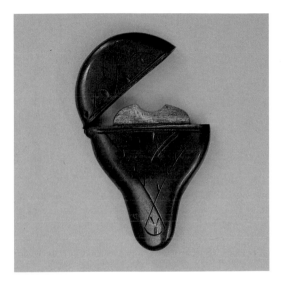

\mathcal{M}other-of-pearl and silver case for bow spectacles with central hinge. 18th century.

Astuccio in madreperla ed argento per occhiali ad arco con perno centrale. Sec. XVIII.

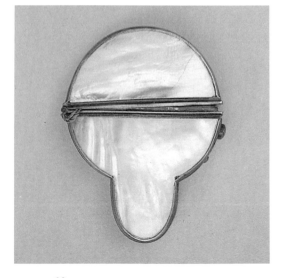

Package for six pairs of copper-wire bow spectacles. The box is in marine pine and has a printed label on the front, with the emblems of Nuremberg. On the packing paper a message, in 18th-century Gothic characters, translates to: "These excellent glass spectacles can be obtained from George William Schmidt, Nuremberg." Mid-18th century.

Cassettina-imballo con sei paia di occhiali ad arco in rame trafilato. La cassettina è in legno di pino marittimo ricoperta, la faccia anteriore, da un ritaglio di carta stampata raffigurante gli stemmi della città di Norimberga. Sulla carta da imballo vi è scritto in caratteri goticosettecenteschi: "Questi ottimi occhiali di vetro Cron si possono avere da Giorgio Guglielmo Schmidt, Norimberga." Metà del sec. XVIII.

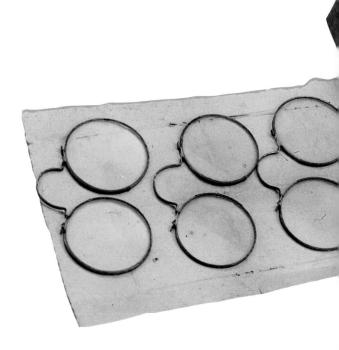

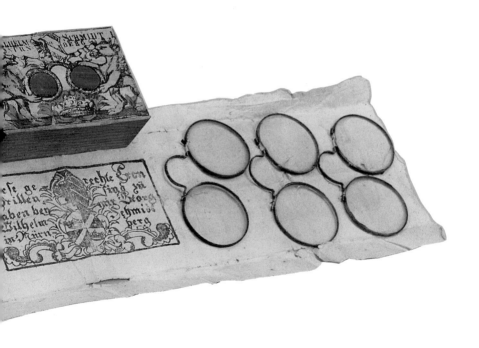

*F*rontispiece of the book *Collection of
Optic Machines and Instruments made in Venice by
Biagio Burlini*, Venice 1758.

Frontespizio del libro Raccolta di macchine ed istru-
menti d'ottica che si fabbricano in Venezia da Biagio
Burlini, *Venezia 1758.*

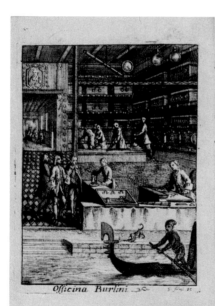

Officina Burlini

RACCOLTA
DI MACCHINE, ED ISTRUMENTI
D'OTTICA
CHE SI FABBRICANO IN VENEZIA
DA BIAGIO BURLINI
Occhialajo fopra la Fondamenta del Rofmarino
all' Infegna dell' ARCHIMEDE

Umiliata a Sua Eccellenza il Signor

GIO: ANTONIO RIVA
PATRIZIO VENETO, E SENATORE
AMPLISSIMO.

IN VENEZIA,
MDCCLVIII.

APPRESSO MODESTO FENZO.
CON LICENZA DE' SUPERIORI.

\mathcal{W}ig spectacles, in metal. The curving rod fits the head under the wig, holding the spectacles firmly in position. Italian, early 18th century.

Occhiali da parrucca in metallo. L'asta curva accompagna la forma del capo sotto la parrucca in modo che gli occhiali rimanessero fermi davanti agli occhi. Inizi sec. XVIII. Manifattura italiana.

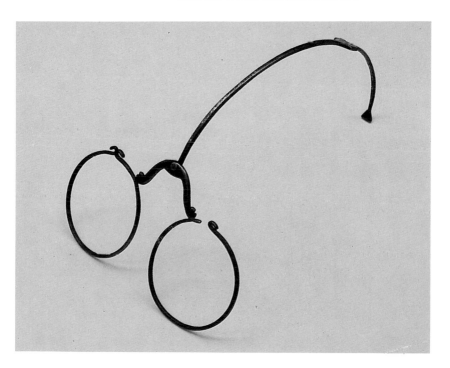

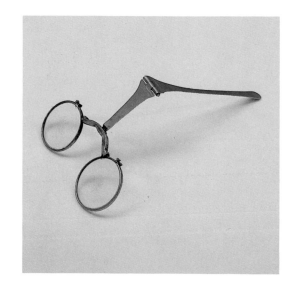

Metal wig spectacles. Early
18th century.

*Occhiali da parrucca in
metallo. Inizi sec. XVIII.*

Temple spectacles, metal.
English, first half of the 18th
century.

*Occhiali tempiali in metallo.
Manifattura inglese. Prima
metà del secolo XVIII.*

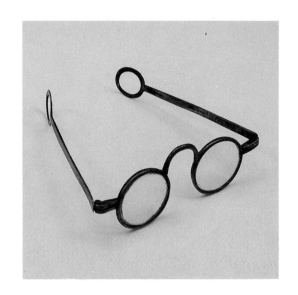

Temple sunglasses, in silver.
The arms end in a spiral motif
to hold the glasses firmly with-
out being excessively painful.
French, first half of the 18th
century.

*Occhiali da sole tempiali in
argento. In questo occhiale le
stanghette terminano con moti-
vo a riccio, premono su una
superficie tempiale maggiore e
quindi gli occhiali hanno mag-
gior stabilità e di conseguenza
meno fastidio se usati a lungo.
Manifattura francese, prima
metè del sec. XVIII.*

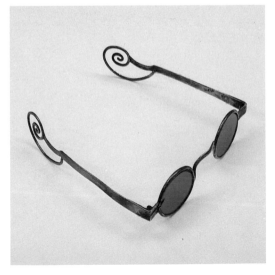

Temple spectacles, in silver. The arms terminate in a large ring that presses on a large area of the head to stabilize the spectacles and make them less painful to use. German, first half of the 18th century.

Occhiali tempiali in argento. Le stanghette terminano con un grande anello per abbracciare una maggior porzione del capo cosÏ che l'occhiale resulti più stabile e meno doloroso. Manifattura tedesca. Prima metà del sec. XVIII.

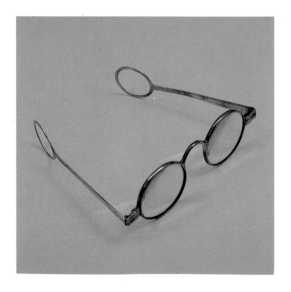

Temple spectacles, with folding arms and iron hinge. This type of arm succeeded the temple arms ending in a ring: the rods grip the sides of the head and when folded, fit within the length of the spectacle frame itself. The lenses are oval and colored green. Second half of the 18th century.

Occhiali tempiali con stanghetta ripiegabile con cerniera in ferro. Questo tipo di stanghette sono seguenti alle tempiali con anello; abbracciano orizzontalmente il capo e ripiegate sono contenute nella lunghezza del frontale. Le lenti sono ovali e di colore verde. Seconda metà del XVIII secolo.

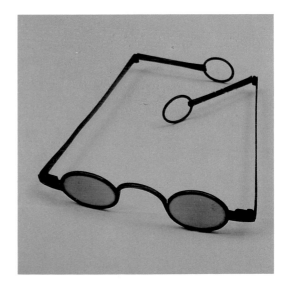

\mathcal{T}emple spectacles in steel, with horn frames designed to eliminate the lens's peripheral flaws. This device was invented by the London optician Martin in 1756. English, second half of the 18th century.

Occhiali tempiali in acciaio con cerchiature sulle lenti in corno per eliminare i difetti periferici della lente stessa, questa soluzione fu inventata dall'ottico londinese Martin nel 1756. Manifattura inglese, seconda metà del sec. XVIII.

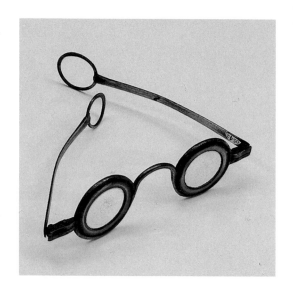

Case with sunglasses of the type known as "Goldoni." Horn, with arms terminating in a ring. At the lateral extremities of the frame are two shades of green silk. Venetian, second half of the 18th century.

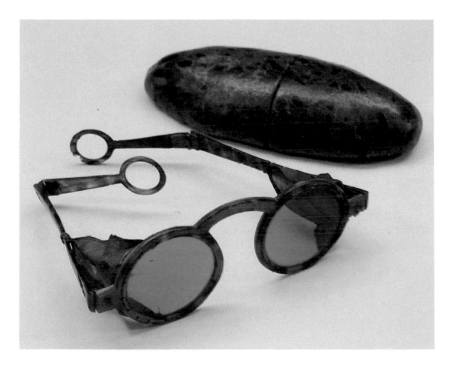

Astuccio con occhiali da sole del tipo detto "Goldoni." Gli occhiali sono in corno con stanghette terminanti con anello. Ai lati tempiali della montatura vi sono due paraocchi in seta verde. Manifattura veneziana, seconda metà del sec. XVIII.

\mathcal{S}pectacles with folding arms,
made of iron. Italian, late 18th century.

Occhiali a stangetta ripiegabili in ferro.
Manifattura italiana, fine sec. XVIII.

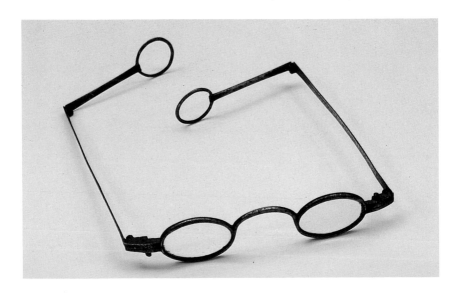

\mathcal{B}aleen spectacles
with temple arms. The frame is
very light; the piece is quite
rare. German, late 18th century.

*Occhiali a stanghetta tempiale
in fanone. La montatura è leg-
gerissima e l'esemplare è piut
tosto raro. Manifattura tedesca,
fine sec. XVIII.*

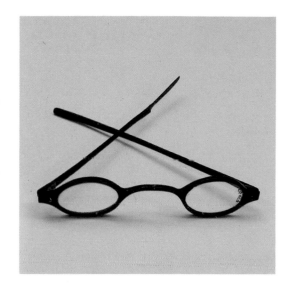

\mathcal{S}pectacles with tele-
scopic arms, in silver, with
small oval sunglass lenses. This
piece is marked "Birmingham"
with a punch that was in use
from 1773 on. English.

*Occhiali a stanghetta estensibili
in argento con piccole lenti da
sole ovali. L'occhiale è pun-
zonato: Birmingham, punzone in
vigore dal 1773. Manifattura
inglese.*

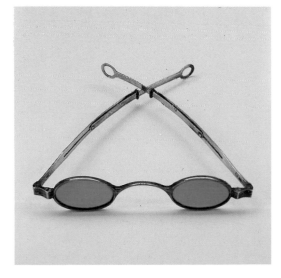

\mathcal{W}ooden spectacle case covered in green "galuchat," with a series of large scales. This luxury material was named after the Parisian craftsman Galuchat, who achieved the effect by means of special hide tanning and varnishing techniques. French, late 18th century.

Astuccio per occhiali in legno rivestito in "galuchat" verde a grosse scaglie degradanti. Il pregiato rivestimento prende nome dall'artigiano parigino Galuchat che trattava la pelle di squalo con speciali lavorazioni di concia e di verniciatura da ottenerne questo effetto. Manifattura francese, fine sec. XVIII.

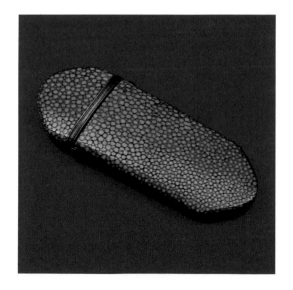

Spectacle case made of cardboard covered with inlays of polychrome straw showing floral motifs. In the upper and lower frames is a monogram, "F.F." The case contains a single pair of spectacles. French, 19th century.

Astuccio per occhiali in cartone rivestito di intarsi di paglia policroma rappresentanti motivi floreali. Nel riquadro superiore e in quello inferiore un solo monogramma: F.E. L'astuccio contiene un paio di occhiali. Manifattura francese sec. XIX.

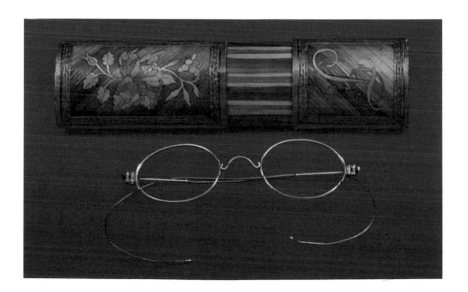

Rugendas, Johannes Lorenz (18th century)

Portrait of Benjamin Franklin (engraving, 34.4 x 22.5 cm). The invention of bifocals is attributed to Benjamin Franklin.

Rugendas, Johannes Lorenz (sec. XVIII)

Ritratto di Benjamin Franklin (incisione, cm. 34.4 x 22.5). A Benjamin Franklin fu attribuita l'invenzione degli occhiali bifocali.

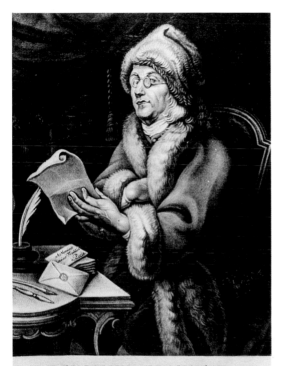

BENJAMIN FRANKLIN.

Né à Boston, dans la nouvelle Angleterre le 17 Janvier 1706.

Th. Lorenz Bayr des fecit et excud. Aug Vind.

\mathcal{S}pectacles with telescopic arms. This type of arm developed from the desire to eliminate the irritating hinge next to the temple. Above: spectacle is marked McAllister. Made in the U.S.A., early 19th century. Below: marked Benz. German, first half of the 19th century.

Occhiali a stanghetta estensibile mediante lo scorrimento di un perno in una fessura a binario. Questo tipo di stanghetta è stata studiata per evitare il fastidio della cerniera contro la tempia. L'occhiale in alto è firmato McAllister. Manifattura americana inizi sec. XIX. L'occhiale in basso è firmata Benz. Manifattura tedesca, prima metà del sec. XIX.

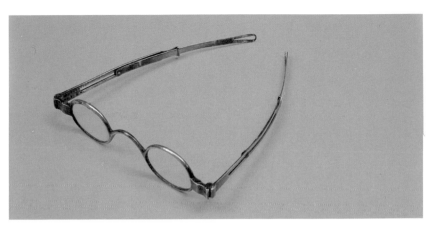

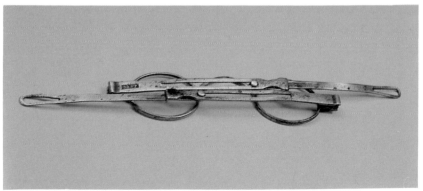

Spectacles in steel and other metal, with folding arms and X-shaped bridge. Second half of the 19th century.

Occhiali a stanghetta ripiegabili in acciaio e metallo. Il ponte è a "X." Seconda metà del sec. XIX.

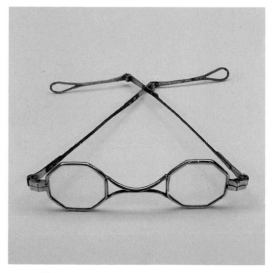

\mathcal{S}pectacles in polished baleen, with round lenses and folding arms, hinged to permit a vertical movement. German, first half of the 19th century.

Occhiale in fanone lucidato con lenti rotonde e stanghetta ripiegabili a perno per permettere un movimento verticale. Manifattura tedesca, prima metà del sec. XIX.

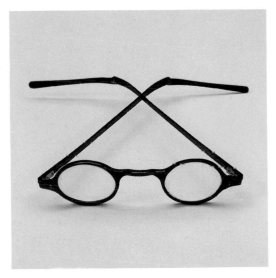

\mathcal{B}riar case for a pair of iron spectacles with folding arms. The date 1826 is engraved inside the case.

Astuccio in radica di noce con occhiali a stanghetta ripiegabili in ferro. All'interno dell'astuccio vi è incisa la data: 1826.

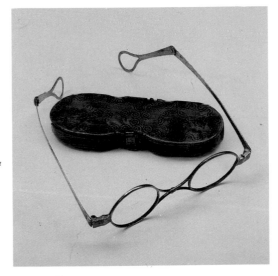

Gold spectacles with telescopic arms. An X-shaped bridge connects the two oval rims, which are fitted with double hinges set forward. French, early 19th century.

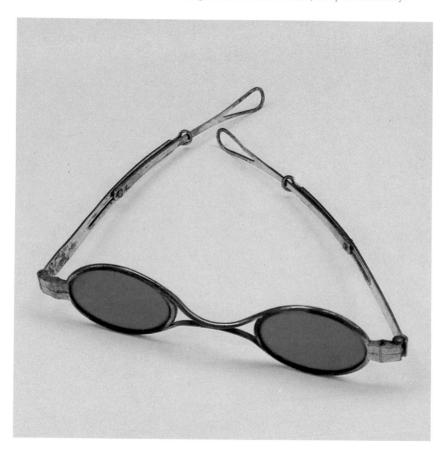

Occhiali in oro con stanghette estensibili. Un ponte ad "X" collega le due cerchiature ovali che presentano all'esterno una doppia cerniera frontale. Manifattura francese, inizi sec. XIX.

Spectacles with telescopic arms and C-shaped bridge. French, early 19th century.

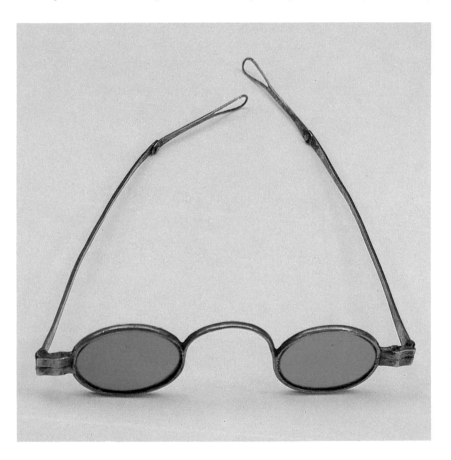

Occhiale a stanghette estensibili con ponte a "C." Manifattura francese, inizi sec. XIX.

\mathcal{S}ilver spectacles with long temple arms that end with two lyres in relief. The punch mark was in use from August 1819. Made in France.

Occhiale in argento a stanghette tempiali lunghe che terminano con due figure di lira a sbalzo. Il punzone è quello in vigore dall'agosto del 1819. Manifattura francese.

\mathcal{S}ilver spectacles with folding arms. French, early 19th century.

Occhiali in argento a stanghette ripiegabili. Manifattura francese, inizi sec. XIX.

\mathcal{C}ase for spectacles with temple arms. The arms are extended using a fixed articulation; the case stores them in this shape. English, 1823.

Astuccio con occhiali a stanghetta tempiali. Le stanghette sono prolungate mediante un perno fisso e l'astuccio li conserva in questa forma. Manifattura inglese 1823.

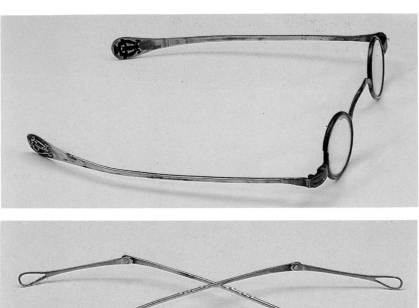

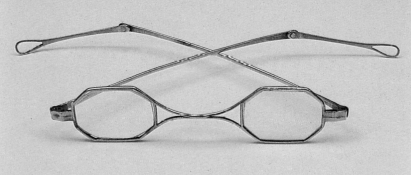

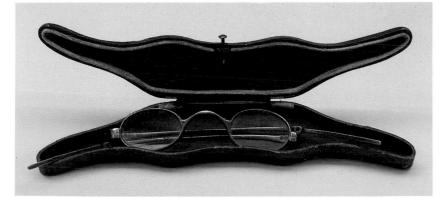

Horn "incroyable," or lorgnette, made in Italy at the beginning of the 19th century. These spectacles are formed of two lenses with a hinged handle. The lenses fold down into the handle, which thus becomes the case as well.

Incroyable in corno. Manifattura italiana, inizi sec. XIX. Questo occhiale è costituito da due lenti con manico perniate che si richiudono ruotando nella custodia che diventa anche manico dell'incroyable.

Silver "incroyable" with mother-of-pearl handle and case. French, early 19th century.

Incroyable in argento con impugnatura-custodia in madreperla. Manifattura francese, inizio sec. XIX.

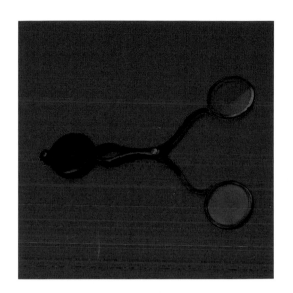

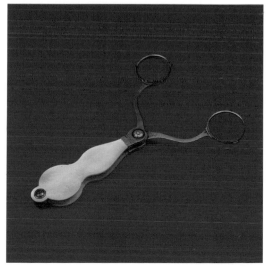

Cast metal "incroyable," gilded and chiseled. French, late 18th to early 19th century. The piece was held at the lower end, with the hand at chin height; sinuous rods were designed to avoid hiding the face.

Incroyable in metallo fuso, dorato e cesellato. Manifattura francese, fine XVIII inizi XIX secolo. L'occhiale si teneva in mano dal basso all'altezza del mento, e le due lenti per mezzo dei sostegni allargati con una linea sinuosa venivano a trovarsi davanti agli occhi, senza comprimere i lineamenti del viso.

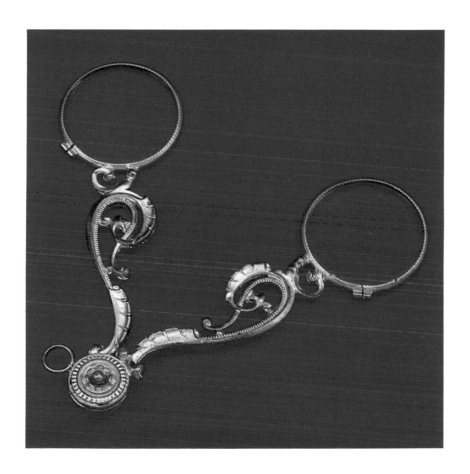

\mathcal{S}pectacles in nickel silver (an alloy of copper, nickel, and zinc whose color varies according to composition) with folding arms. 19th century.

Occhiali in alpacca (lega formata da rame, nichel e zinco, di colore variabile a seconda della composizione) a stanghette ripiegabili. Sec. XIX.

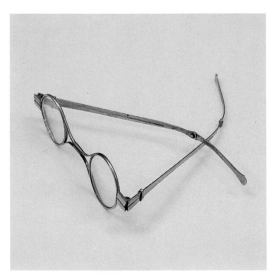

"*Incroyable*" in mottled tortoiseshell. Made in Naples in the mid-19th century. A rare piece because of its handle, on which a carved flower, set on a spring hinge, hides the opening mechanism.

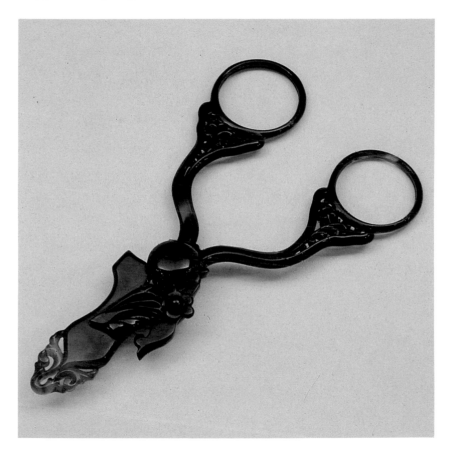

Incroyable in tartaruga jaspée. Manifattura napoletana, metà sec. XIX. Raro occhiale perché presenta una impugnatura sulla quale un fiore scolpito, manovrato da un perno a molla, nasconde il meccanismo per l'apertura.

\mathcal{B}oilly, Louis Leopold (circa 1825)
Les lunettes. Colored lithograph, 30 x 20.5 cm.

Boilly, Louis Leopold (1825 c.)
Les lunettes. Litografia colorata, cm. 30 x 20.5.

\mathcal{F}ace-à-main, or lorgnette, with long handle, in gold and gilded, chiseled silver. Made in Moscow by Fabergé during the first half of the 19th century.

Face-à-main ad impugnatura lunga in oro e argento cesellato e dorato. Manifattura moscovita di Fabergé, prima metà del sec. XIX.

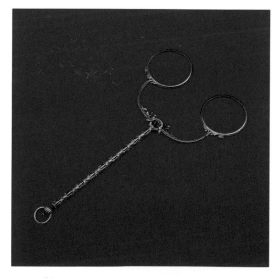

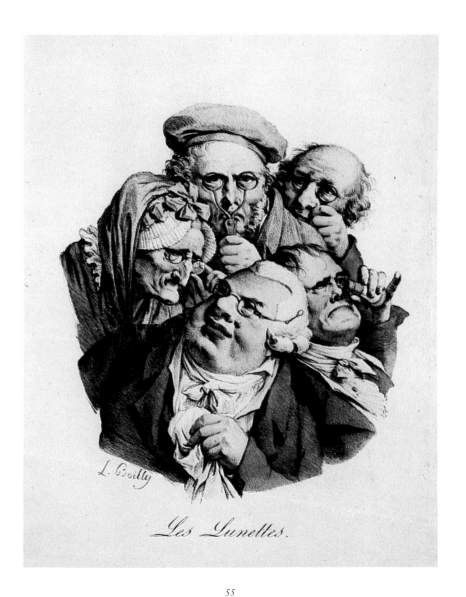

Les Lunettes.

L. Boilly

\mathcal{L}orgnette with handle acting as a case, made in horn. Made in Vienna, mid-19th century. "Lorgnette" derives from "lorgnon," the French term for a small pair of spectacles hanging from a chain or ribbon, used during the 1820s.

Lorgnette con imugnatura a custodia, in corno. Manifattura viennese, metà sec. XIX. Lorgnette deriva da lorgnon che è il termine francese per designare l'occhialetto appeso a una catena o ad un nastro, usato nel 1820.

\mathcal{L}orgnette with fixed front and handle case in tortoiseshell. Made in Vienna, late 19th century.

Lorgnette a frontale fisso con impugnatura-custodia in tartaruga. Manifattura viennese, fine sec. XIX.

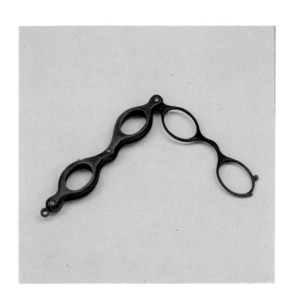

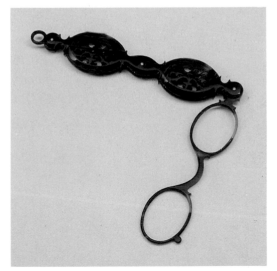

Face-à-main, or lorgnette, with a handle in the form of a watch with an ornate chatelaine chain. The lenses are held by curved segments of gilded metal, hinged so that they can be folded one onto the other and then closed into the medallion, like a pocket watch. French, mid-19th century.

Face-à-main con impugnatura a forma di orologio con châtelaine. Le lenti sono rette da segmenti curvilinei in metallo dorato incernierati in modo da essere sovrapponibili e chiusi dentro il medaglione come un orologio da tasca. Manifattura francese, metà sec. XIX.

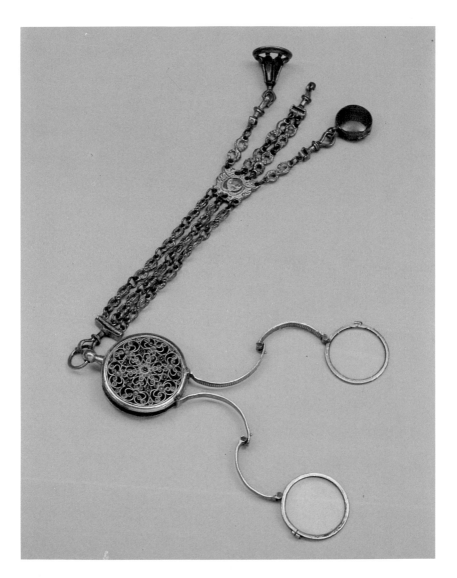

\mathcal{L}orgnette in gilded silver with red gold inlay and polychrome enamel. French, second half of the 19th century.

Lorgnette in argento dorato con intarsi in oro rosso e smalti policromi. Manifattura francese, seconda metà sec. XIX.

\mathcal{L}orgnette with fixed front, and handle case in nickel-plated silver finished with blue enamel. Made in Middle Eastern Europe, 19th century.

Lorgnette a frontale fisso con impugnatura-custodia in argento niellato con smalto blu. Manifattura dell'Europa medio-orientale sec. XIX.

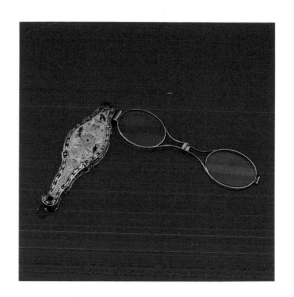

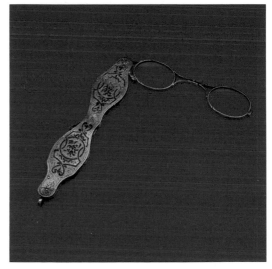

\mathcal{L}orgnette in chiseled gold, with blue inlaid enamel. The front was folded by means of a hinge, and, when open, was held firm by a catch set in the handle. Made in Ireland, late 19th century.

Lorgnette in oro cesellato con intarsi di smalto blu. Il frontale è chiudibile sovrapponendo le lenti con un sistema a perno e tenendole ferme con un meccanismo a scatto incastrato nell'impugnatura. Manifattura irlandese, fine sec. XIX.

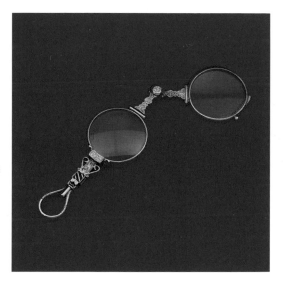

\mathcal{L}orgnette with handle case in cast and chiseled silver. When not in use, the spectacles were folded at the bridge so that the lenses lay one on the other, and kept in the Art Nouveau-style handle, decorated with a design of horse-chestnut branches and foliage. French, late 19th to early 20th century.

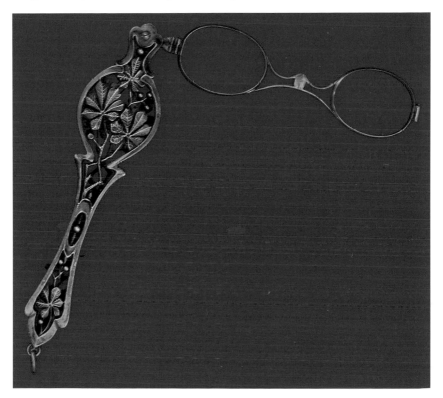

Lorgnette con impugnatura-custodia in argento fuso e cesellato. Quando non si adopera l'occhiale, il ponte si piega nel mezzo e le lenti si sovrappongono e si custodiscono nella bella impugnatura di stile liberty decorata con rami e foglie di ippocastano. Manifattura francese, fine sec. XIX inizi XX.

\mathcal{L}orgnette with a
long silver handle formed of
intertwined snakes. Late 19th
to early 20th century.

*Lorgnette ad impugnatura
lunga in argento costituita da
un intreccio di serpenti. Fine
sec. XIX inizi XX.*

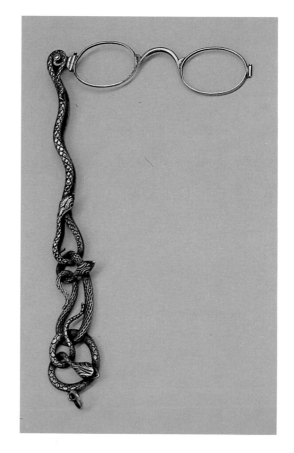

\mathcal{L}orgnette of blond tortoiseshell with long handle. Italian, late 19th century.

Lorgnette in tartaruga bionda ad impugnatura lunga. Manifattura italiana, fine sec. XIX.

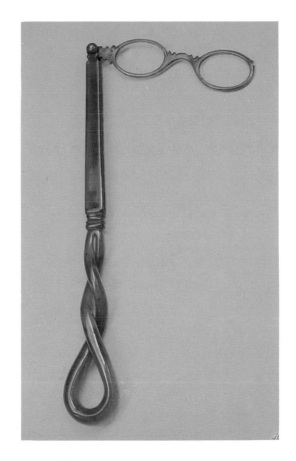

Lorgnette in chiseled silver. Italian, early 20th century.

Lorgnette in argento cesellato. Manifattura italiana, inizi sec. XX.

Lorgnette with long silver handle in the form of ribbons, bows, and flowers and covered in garnets and marcasite. Late 19th to early 20th century.

Lorgnette a impugnatura lunga in argento costituita da un'asta cinta da nastri, fiocchi, fiori, ricoperta da granati e marcassiti. Fine sec. XIX inizi XX.

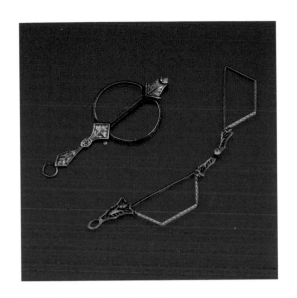

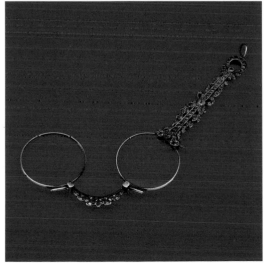

\mathcal{L}orgnette with silver handle case. Italian, late 19th to early 20th century.

Lorgnette con impugnatura-custodia in argento.
Manifattura italiana, fine sec. XIX inizi XX.

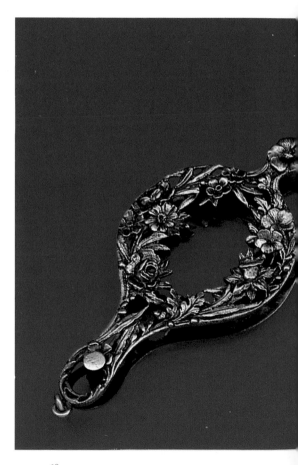

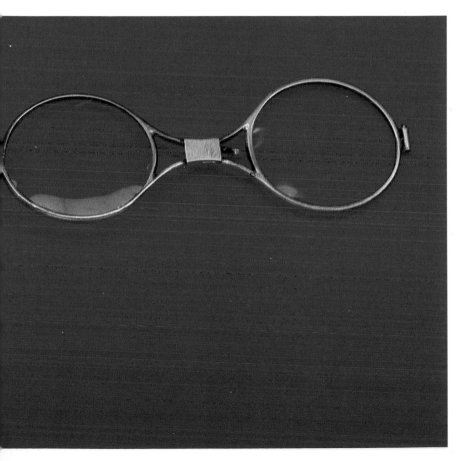

Case with spectacles made in silver and glass. This type of spectacles was devised around 1830 by the opticians Voigländer and Waldstein of Vienna. The front is entirely of glass, including the bridge molded into concave or convex form corresponding to the lenses.

Astuccio con occhiali in cristallo e argento. Questo tipo di occhiali fu creato verso il 1830 dagli ottici Voigländer e Waldstein di Vienna. Il frontale è interamente di cristallo ed assume, in corrispondenza della lente, la concavità relativa alle esigenze diottriche.

Glass and silver spectacles of the "Waldstein" type. Made in Vienna, first half of the 19th century.

Occhiali in cristallo e argento tipo "Waldstein." Manifattura viennese. Prima metà del sec. XIX.

Steel "wire" spectacles with folding arms and a K-shaped bridge. French, second half of the 19th century.

Occhiali a stanghetta ripiegabili in acciaio con ponte a "K" detti "fili." Manifattura francese. Seconda metà del sec. XIX.

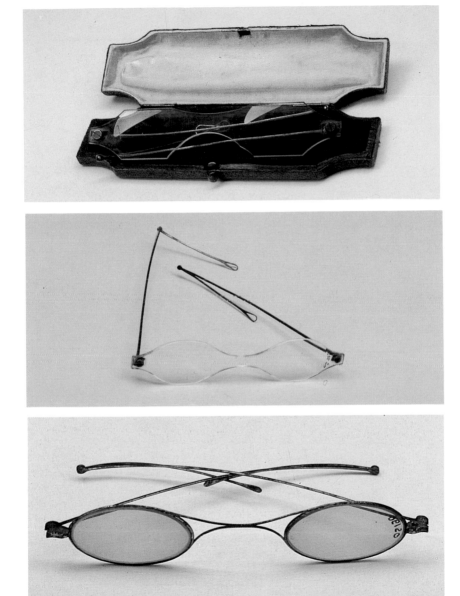

Wire spectacles from the late 19th century.

Insieme di occhiali detti "fili," fine sec. XIX.

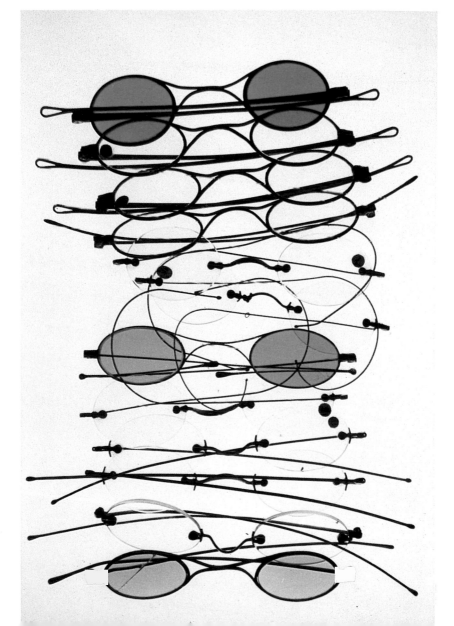

\mathcal{T}ortoiseshell spectacles with "spatula" temple arms. French, second half of the 19th century.

Occhiali in tartaruga a stanghette tempiali dette a "spatola." Manifattura francese, seconda metà del sec. XIX.

\mathcal{S}teel spectacles with long temple arms. French, late 19th century.

Occhiali in acciaio a stanghette tempiali lunghe. Manifattura francese, fine sec. XIX.

\mathcal{T}ortoiseshell spectacles with folding arms. French, second half of the 19th century.

Occhiali a stanghette ripiegabili in tartaruga. Manifattura francese, seconda metà del sec. XIX.

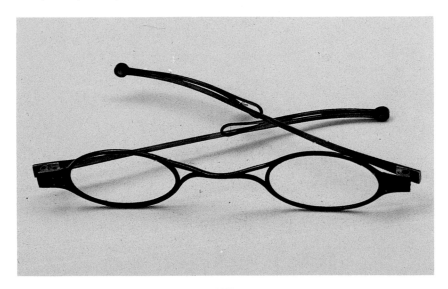

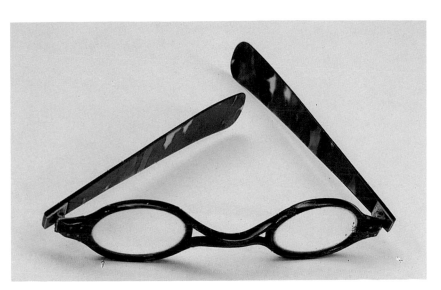

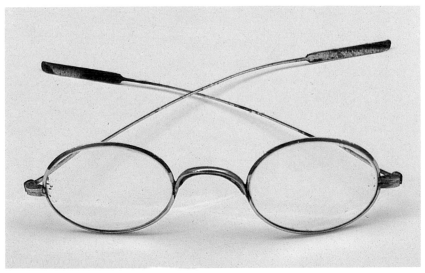

Steel spectacles with long temple arms and lateral sunshades in green fabric. French, late 19th century.

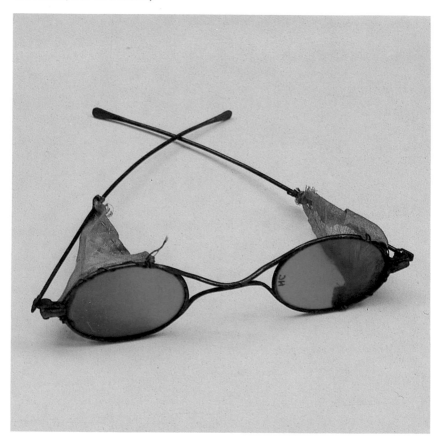

Occhiali in acciaio a stanghette tempiali lunghe con paraluce laterali in tessuto verde. Manifattura francese, fine sec. XIX.

\mathcal{S}unglasses with folding arms and "horseshoe" frames. The double lenses can be moved sideways to shade the eyes. This invention is attributed to the optician Richardson and dates from the late 18th century: it was in use during the 19th century.

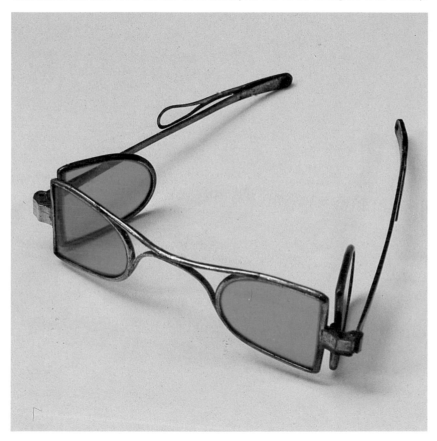

Occhiali da sole con stanghette ripiegabili. Le lenti sono doppie, snodabili lateralmente per riparare gli occhi dalla luce. Questra invenzione è attribuita all'ottico Richardson alla fine del sec. XVIII ed in uso nel XIX secolo. La montatura è detta a "ferro di cavallo."

Silver spectacles with folding arms: another Richardson model with lenses that, when superimposed, increase the dioptric strength. English, mid-19th century.

Occhiali in argento a stanghette ripiegabili tipo Richardson con lenti che sovrapponendosi aumentano le diottrie positive. Manifattura inglese, metà del sec. XIX.

Metal spectacles with folding arms, a Richardson model with oval, green-tinted lenses that can be combined with the blue lenses on lateral pivots. Mid-19th century.

Occhiali in metallo a stanghette ripiegabili tipo Richardson con lenti ovali di colore verde che si uniscono con quelle di colore blue apribili lateralmente. Metà sec. XIX.

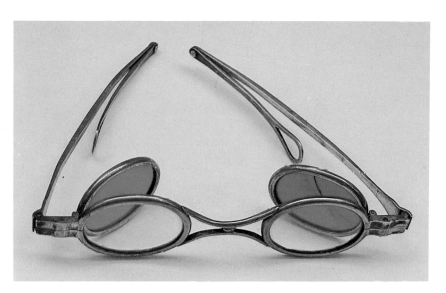

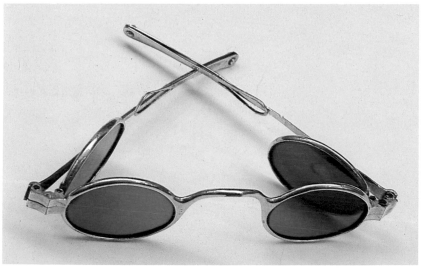

Spectacles with vertically folding arms using a ball-and-socket pivot. The front is of "horseshoe" form and the lenses are double, Richardson type. German, mid-19th century.

Occhiale a stanghette ripiegabili in senso verticale mediante un perno a globo. Il frontale è detto a "ferro di cavallo," le lenti sono doppie tipo Richardson. Manifattura tedesca, metà del sec. XIX.

Silver spectacles with folding arms, a Richardson model with uncolored fixed lenses and additional, mobile lenses tinted blue. Punched "Birmingham 1827," the piece also bears the manufacturer's initials "L&C." English, mid-19th century.

Occhiali in argento a stanghette ripiegabili tipo Richardson con lenti fisse neutre e quelle sovrapponibili di colore blu. I punzoni di Birmingham 1827 con la sigla del fabbricante "L&C." Metà del sec. XIX.

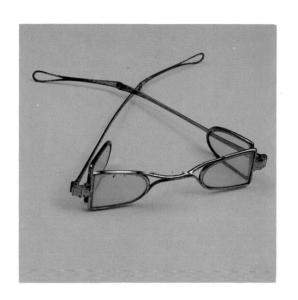

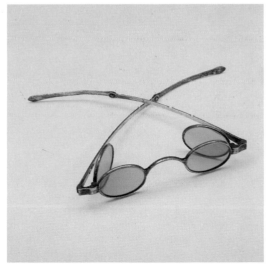

\mathcal{S}pectacle case in filigree silver, with chain attachment, a large hook decorated with a three-petaled flower. Late 19th century.

Astuccio per occhiali in filigrana d'argento con châtelaine retta da un grosso gancio decorato da un fiore a tre petali. Fine sec. XIX.

\mathcal{W}ooden, book-form case covered in tortoiseshell with inlaid floral motifs and garlands in gold. English, late 19th to early 20th century.

Astuccio a libro in legno ricoperto di tartaruga con intarsio di serti floreali e festoni in oro. Manifattura inglese fine sec. XIX inizi sec. XX.

\mathcal{S}pectacle case made of white mother-of-pearl, with pink and green iridescent colors. Early 19th century.

Astuccio per occhiali in madreperla bianca con cangiantismi rosa e verde. Inizi sec. XIX.

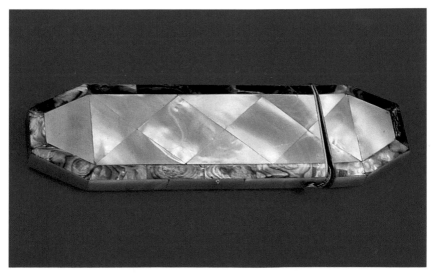

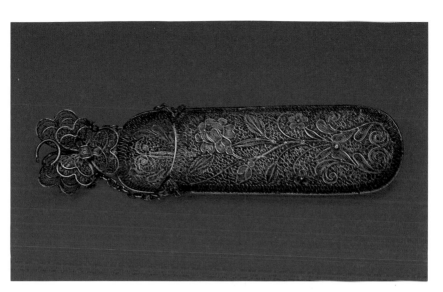

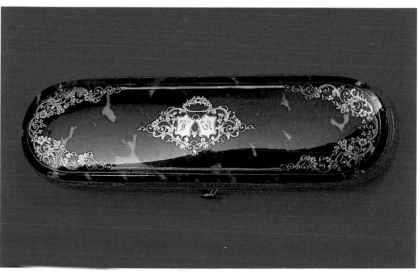

Pince-nez in cast and chiseled silver. When closed, the lenses are superimposed and the figures on the rims meet, completing the scene of a cat catching a mouse. French, mid-19th century.

Occhiali a stringinaso in argento fuso e cesellato. In posizione di chiusura cioè sovrapponendo le lenti le figurine sulle singole cerchiature si incontrano realizzando la scenetta in cui il gatto afferra il topo. Manifattura francese, metà sec. XIX.

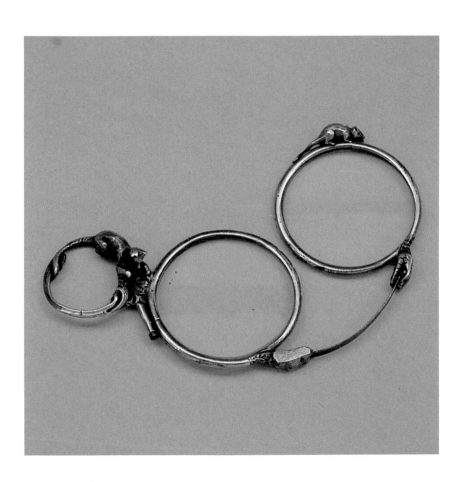

\mathcal{S}teel pince-nez and case marked "Prof. Neuschuler." French, early 20th century.

Stringinaso in acciaio custoditi in astuccio siglato Prof. Neuschuler. Manifattura francese, inizio sec. XX.

\mathcal{S}pectacles in white horn, with temple arms. Italian, late 19th century.

Occhiali a stanghette tempiali in corno bianco. Manifattura italiana, fine sec. XIX.

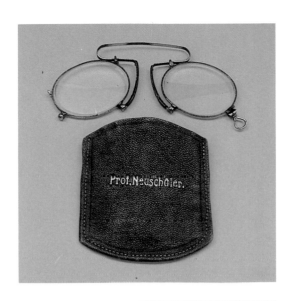

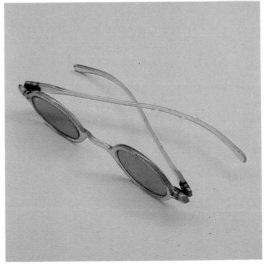

Tortoiseshell pince-nez with steel spring and short arms that terminate in eyelets. French, late 19th century.

Occhiali a stringinaso in tartaruga con molla in acciaio, stanghette laterali corte terminanti con asole. Manifattura francese, fine sec. XIX.

Rimless pince-nez. Italian, late 19th century.

Occhiali stringinaso senza cerchiatura "a giorno." Manifattura italiana, fine sec. XIX.

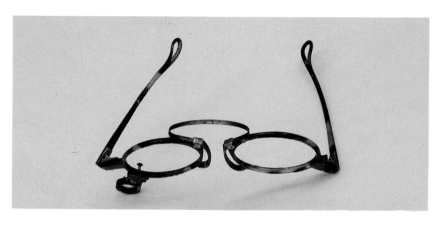

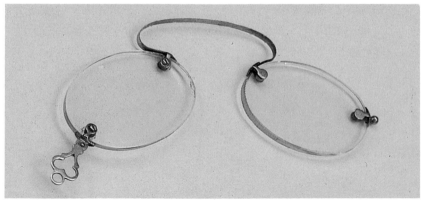

\mathcal{P}ince-nez in horn, with spring bridge. This model is known as "Kaiser" and has green-tinted lenses. Made in Austria in 1900.

Stringinaso in corno con ponte a molla. Le lenti sono verdi, il modello è detto "Kaiser." Manifattura austriaca, 1900.

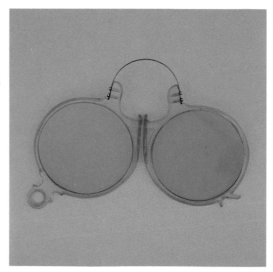

\mathcal{P}ince-nez with plastic rims and a gold-plated spring bridge. "One piece" model, made in the U.S.A. by Bausch and Lomb, early 20th century.

Stringinaso con cerchi in materiale plastico, pone a molla placcato oro. Modello "One piece," manifattura americana (Bausch & Lomb), inizi sec. XX.

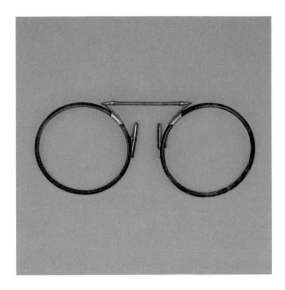

\mathcal{T}wo plastic pince-nez. Below, the "FITS-U," the last model of pince-nez produced by the American Optical Company, U.S.A., in 1915.

Due stringinaso in materiale plastico. Il modello in basso detto "FITS-U" è l'ultimo stringinaso sopraggiunto dagli Statu Uniti (American Optical Company) nel 1915.

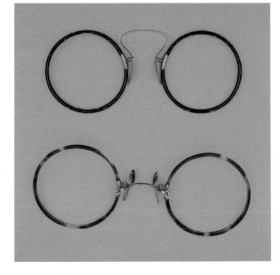

\mathcal{I}ron wire spectacles with a strong saddle-bridge and lateral attachments for ribbons used to tie the glasses to a gas mask, used by Austrian and German troops during World War I.

Occhiali in ferro trafilato con robusto ponte a sella e attacchi tempiali per le fettucce da ancorare alla maschera antigas in dotazione alle truppe austriache e tedesche durante la prima guerra mondiale.

\mathcal{P}rotective pince-nez often used by train passengers. German, early 20th century.

Occhiali stringinaso, di protezione, usati abitualmente dai passeggeri del treno. Manifattura tedesca, inizio sec. XX.

\mathcal{S}pectacles with protective arms, fitted with steel nets, used by passengers during train journeys. German, late 19th century.

Occhiali a stanghette protettie con retine laterali in acciaio, usate dai passeggeri durante i viaggi in treno. Manifattura tedesca, fine sec. XIX.

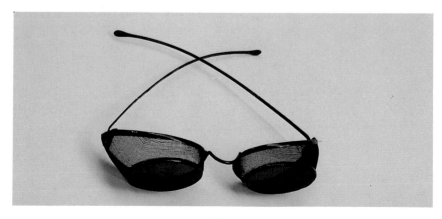

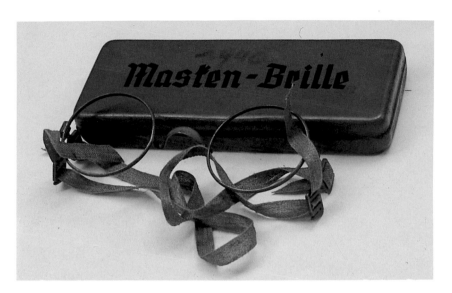

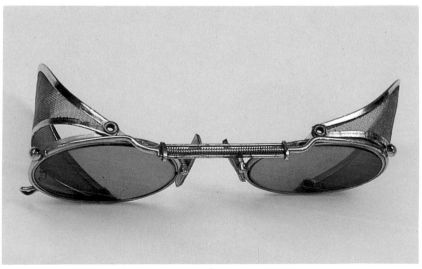

Nickel spectacles with adjustable arms and curved ear-pieces. German, early 20th century.

Occhiali in nichel a stanghette inclinabili. Manifattura tedesca, inizio sec. XX.

Spectacles with curved ear-pieces. The frames are celluloid-covered metal. "Windsor" model made by the American Optical Company, early 20th century.

Occhiali a stanghette auricolari con montatura in metallo ricoperto di celluloide, modello "Windsor." Manifattura americana (American Optical Company), inizi sec. XX.

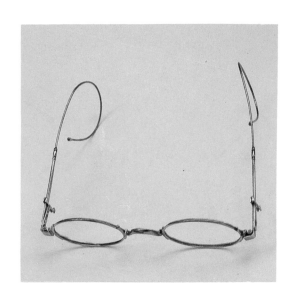

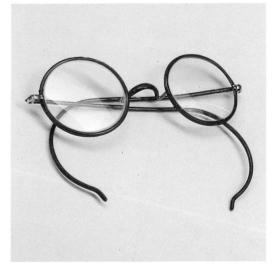

"*P*antoscopic" spectacles with metal frames (with plastic on the arm ends and above the lenses). Made in Austria, 1950.

Occhiali con montatura in cello-metallo (materiale plastico usato per aste e frontale) a forma pantoscopica. Manifattura austriaca, 1950.

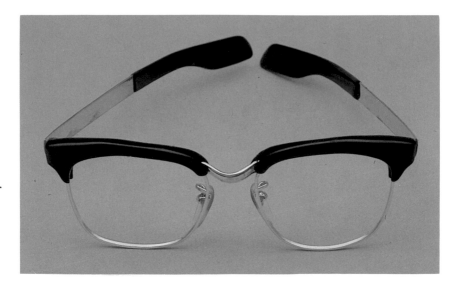

\mathcal{G}old-plated spectacles with curved ear-pieces. "Full-view" model, PEX type. English, 1960.

Occhiali a stanghetta auricolare placcati oro modello "Full-view," tipo PEX. Manifattura inglese, 1960.

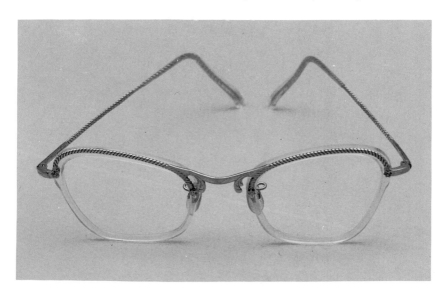

Optyl sunglasses with details in gilded metal and enamel. Optyl, a light and flexible plastic invented in 1967 by the Austrian chemist Anger, was adopted by Christian Dior in 1969, who designed the first range of eyeglasses in contemporary style. This example can be considered the ancestor of fashion glasses.

Occhiali da sole in optyl con applicazioni in metallo dorato e smalti. L'optyl, materiale plastico di grande flessibilità e leggerezza, fu inventato nel 1967 dall'austriaco Anger e sfruttato da Christian Dior nel 1969 che mise a punto la prima linea di occhiale legato all'evoluzione della moda, di cui qusto esemplare può considerarsi il capostipite.

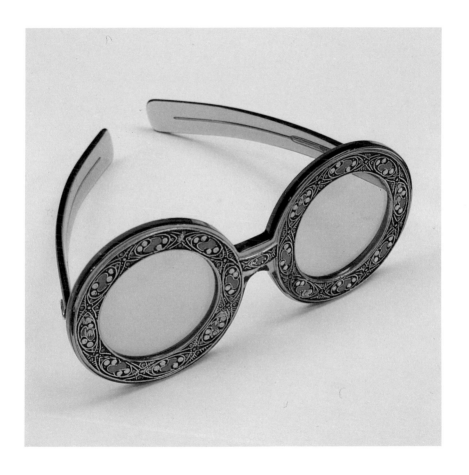

Non-European Spectacles

Bamboo case and tortoiseshell spectacles with lenses in rock crystal. At the sides of the frame are two eyelets for cords that served to hold the glasses in place. This unsteady system is one of the many design failures that punctuate the history of spectacles. Made in China, late 17th to early 18th century.

Astuccio in legno di bambù con occhiali in tartaruga e lenti in cristallo di rocca. Sulla montatura lateralmente vi sono due asole dove venivano infilati due cordoncini che servivano a tener fermi gli occhiali davanti agli occhi. Questo fu uno dei tanti tentativi destinati a fallire per la precarietà. Manifattura cinese, fine sec. XVII inizi sec. XVIII.

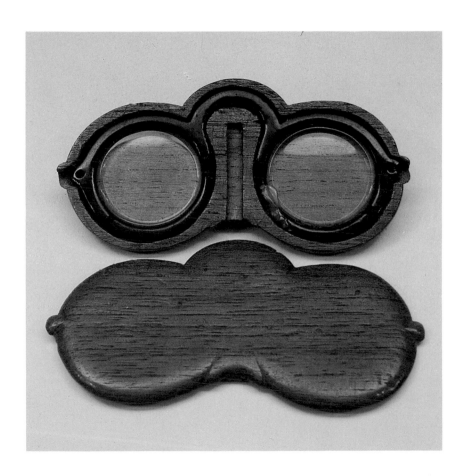

\mathcal{S}pectacles with bridge and arms of "pack-fong," an alloy of silver, nickel, and brass. The glasses have no dioptric strength and were in fact used merely to reinforce the social and intellectual status of the wearer. Made in China, 18th century.

Occhiali con ponte e stanghette in packfong. Packfong è una lega di argento, nikel e ottone. Questi occhiali avendo lenti neutre erano di rappresentanza e conferivano dignità di alto rango sia sociale sia intellettuale a chi li indossava. Manifattura cinese, sec. XVIII.

\mathcal{B}rass spectacles with folding arms and slightly yellow-tinted beryl lenses. Made in China, 18th century.

Occhiali a stanghette ripiegabili in ottone. Le lenti sono in berillo leggermente colorate di giallo. Manifattura cinese, sec. XVIII.

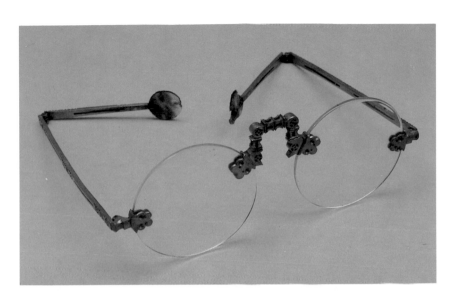

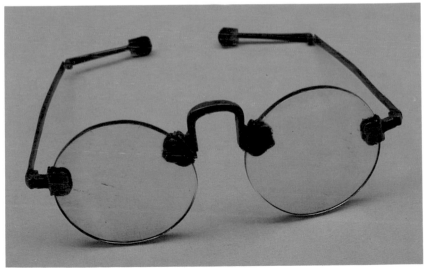

\mathcal{R}ock-crystal spectacles, with brass bridge and arms. At the end of the arms are two plates, pierced with the ideogram for longevity. Made in China, 18th century.

Occhiali in cristallo di rocca con ponte e stanghette in ottone. Le stanghette terminano con palette recanti al centro un traforo formante l'ideogramma della longevità. Manifattura cinese, sec. XVIII.

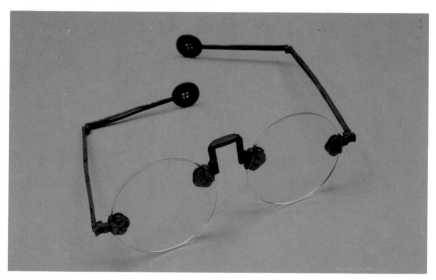

Tortoiseshell spectacles with folding arms and brass hinge. The rims are in jaspée tortoiseshell with a pierced, filigree-type bridge. Made in China, 18th century.

Occhiali in tartaruga a stanghette ripiegabili con cerniera in ottone. Il frontale è in tartaruga jaspée con ponte traforato. Manifattura cinese, sec. XVIII.

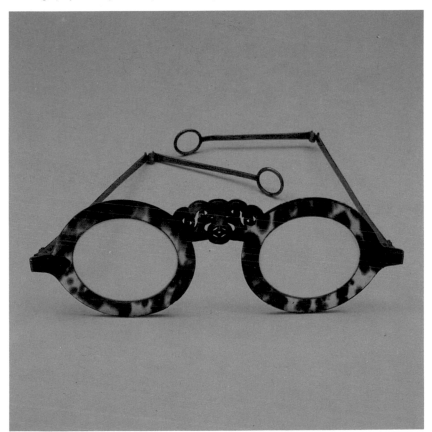

\mathcal{V}ertical spectacle case. Black silk, with beads and crystals that form a pattern of plum-tree branches in flower. According to Chinese symbology, the plum flower and the ivory handle indicate that the case belonged to a man of letters; the black background shows that its owner was also a distinguished magistrate who had retired due to advanced age. Made in China, 18th century.

Astuccio verticale per occhiali. Seta nera con applicazioni di conterie e cristalli a costituire diversi rami con fiori di susino. Nella simbologia cinese mentre il fiore di susino e il pomolo d'avorio indicano la provenienza di questo portaocchiali da un letterato, il colore nero di fondo simboleggia l'appartenenza ad un alto magistrato che ha cessato il suo servizio per tarda età. Manifattura cinese, sec. XVIII.

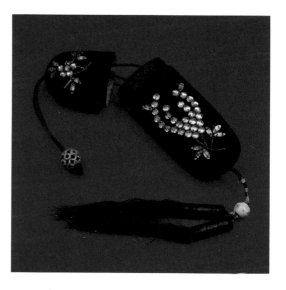

Vertical spectacle case, covered in silk. Two dragons are embroidered on one side, with waves on the other, typical decorations used in court dress and objects. The lid runs along a white silk cord with a porcelain sphere at the end, painted with a peach flower and fruit, symbol of longevity. Made in China, 18th century.

Astuccio verticale per occhiali rivestito in seta. Su una faccia sono ricamati due draghi, sull'altra onde, presenti abitualmente nelle vesti e negli oggetti della corte. Il coperchio scorre lungo un cordoncino di seta bianca terminante con una sferetta di porcellana dipinta con fiore e frutto di pesco simbolo di longevità. Manifattura cinese, sec. XVIII.

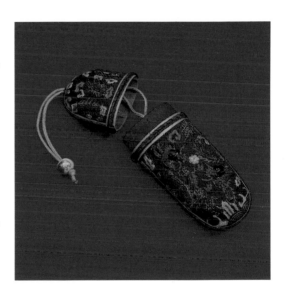

Sunglasses in tinted beryl. The packfong arms end in tortoiseshell discs. Made in China, 18th century.

Occhiali da sole in berillo colorato. Le stanghette sono in packfong e terminano con dischetti in tartaruga. Manifattura chinese, sec. XVIII.

Sunglasses in speckled tortoiseshell. The wide bridge and arms are adorned with symbols of good fortune enclosed within decorative shapes. Supposedly the dark lenses were worn during an audience with the Emperor, so as not to be dazzled by the light shining from the Emperor of the Sun. Made in China, 18th century.

Occhiali da sole in tartaruga maculata. Il ponte e le stanghette sono abbastanza larghe e recano forme decorative che racchiudono forme benaugurali. Si dice che le lenti scure venivano indossate da colui che si presentava al cospetto dell'imperatore per non essere colpito dalla luce del sole-imperatore. Manifattura cinese, sec. XVIII.

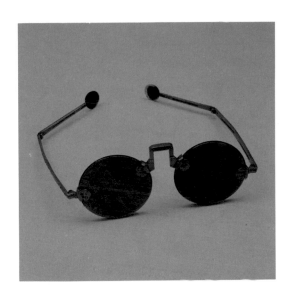

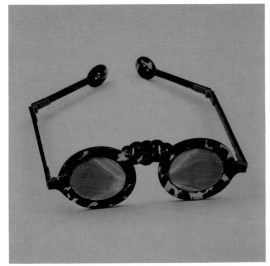

Tortoiseshell spectacles with folding arms
that terminate in two small plates, like the bridge. The
size of this example indicates that the glasses belonged
to a child of noble birth. Made in China, late 18th or
early 19th century.

*Occhiali in tartaruga a stanghette pieghevoli terminanti
con due piccole palette traforate così come il ponte.
Questi occhiali per le piccole dimensioni possono essere
appartertenuti ad un bambino di altissimo rango.
Manifattura cinese sec. XVIII inizi XIX.*

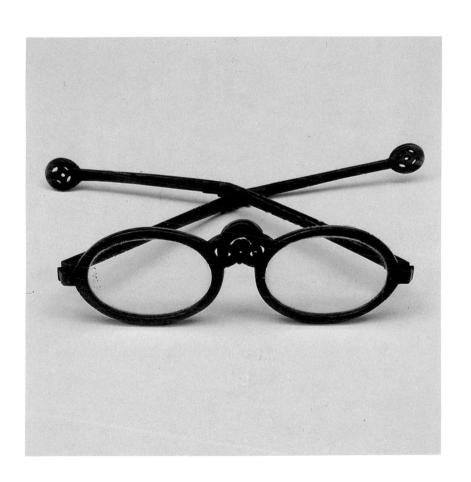

\mathcal{V}ertical spectacle case in enamel and cloisonné. Made in China, early 20th century.

Astuccio verticale per occhiali in smalto e smalto cloisonné. Manifattura cinese, inizi sec. XIX.

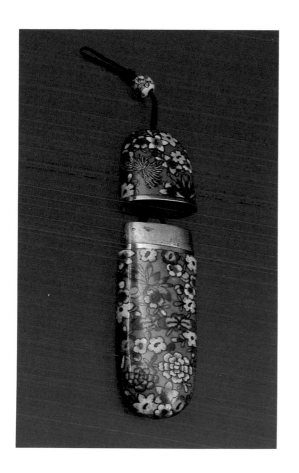

\mathcal{I}vory case, delicately inlaid with compositions of Buddhist philosophers and their followers in gardens with willows. Made in China, early 19th century.

Astuccio in avorio intarsiato finemente con composizioni raffiguranti alcuni filosofi buddisti con i loro discepoli entro giardini con salici. Manifattura cinese, inizio sec. XIX.

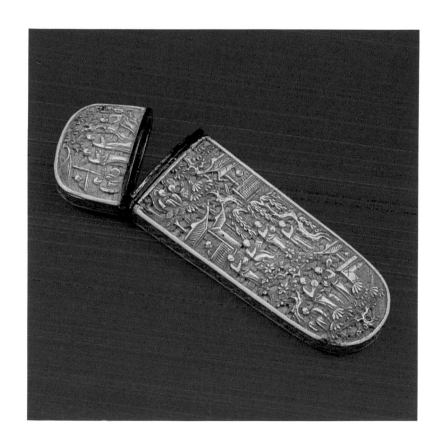

\mathcal{S}pectacles with folding arms, tortoiseshell rims, and beryl lenses. The bridge and arms are brass. Made in China, late 18th century.

Occhiali a stanghetta ripiegabili. Le due cerchiature in tartaruga incorniciano le lenti in berillo trasparente. Il ponte e le stanghette sono in ottone. Manifattura cinese, fine sec. XVIII.

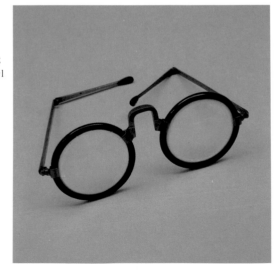

\mathcal{S}pectacles with curved silver arms. The frames were made in India. Late 19th century.

Occhiali con stanghetta a riccio d'argento. La montatura è di manifattura indiana. Fine sec. XIX.

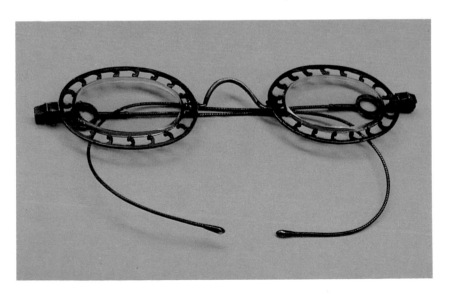

Monocles

Giovanni Lorenzo Haid after Giovanni
Battista Piazzetta (18th century). *Young Man with
Monocle*. Engraving, 38.5 x 26.5 cm.

*Giovanni Lorenzo Haid da Giovanni Battista Piazzetta
(sec. XVIII).* Giovane con monocolo. *Incisione, cm.
38.5 x 26.5.*

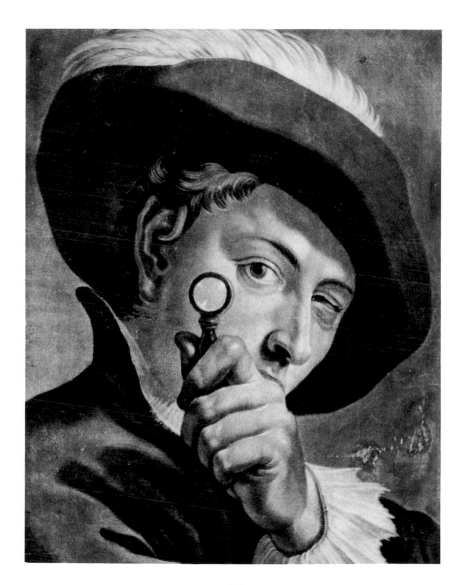

Gold monocle. The handle shows a hand gripping a bundle of rods. 19th century.

Monocolo in oro. Líimpugnatura é risolta da una mano che stringe un fascio di verghe. Sec. XIX.

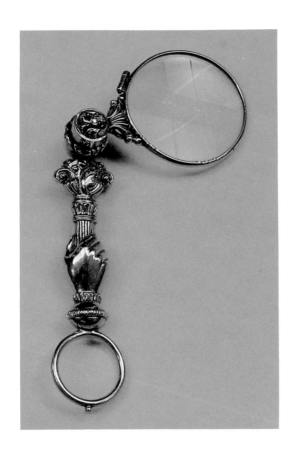

Monocle in burnished metal, with rectangular lens. French, late 19th century.

Monoclo in metallo brunito con lente rettangolare. Manifattura francese, fine sec. XIX.

Silver monocle. The handle is composed of two rampant lions bearing a basket of fruit. French, 19th century.

Monocolo in argento. L'impugnatura è costituita da due leoni rampanti che reggono un cesto di frutta. Manifattura francese, sec. XIX.

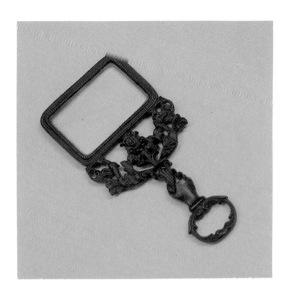

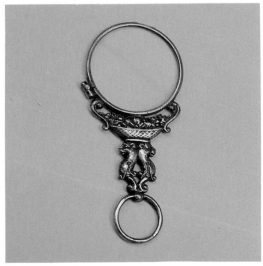

\mathcal{G}old monocle. The handle is embellished with a flower formed of five turquoise stones around a diamond. French, late 19th century.

Monocolo in oro. L'impugnatura è impreziosita da cinque turchesi che formano un fiore con al centro un brillante. Manifattura francese, fine sec. XIX.

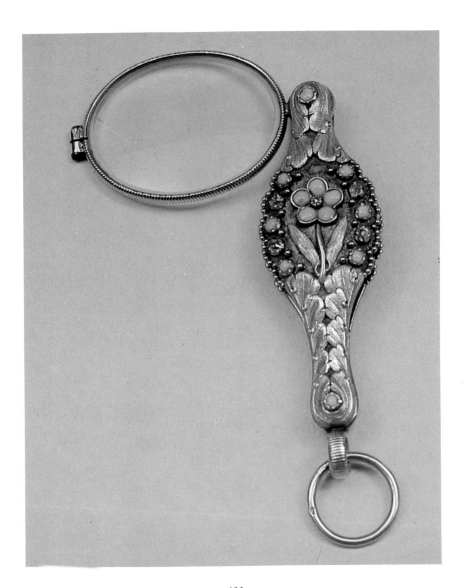

Magnifying Glasses for Reading

Magnifying glass with buffalo-horn case. Made in
Venice, late 18th century.

Lenta da lettura con custodia in corno di bufalo.
Manifattura veneziana, fine sec. XVIII.

Silver magnifying glass. English, 1905.

Lente da lettura in argento. Manifattura inglese, 1905.

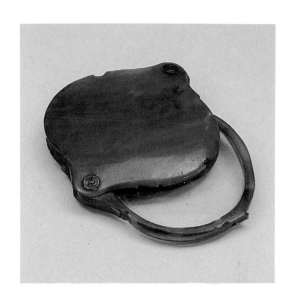

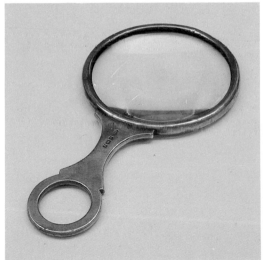

Silver magnifying glass with handle in the shape of a sailing ship. English, late 19th or early 20th century.

Lente da lettura in argento con impugnatura a forma di veliero. Manifattura inglese, fine sec. XIX inizi XX.

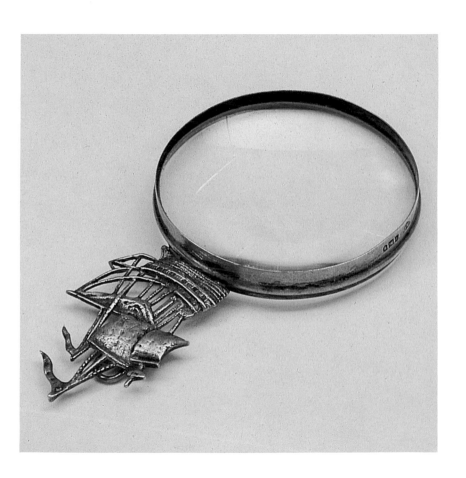

*A*ntique eyewear has been virtually ignored up until a few decades ago. In the late nineteenth century, a few worthy ophthalmologists began to study the history of spectacles, but only one or two aged opticians actually collected them. Recently interest in the subject has grown, and numerous collectors and antique dealers operate in the field.

Though my own collection includes many important pieces, it still lacks specimens from the fourteenth and fifteenth centuries; I hope to fill this gap with the help of a new generation of collectors. I was pleased to work with the publishers on this book, as it represented an opportunity to provide technical and historical information for the benefit of recently converted enthusiasts, thus aiding them in the classification of their pieces. I would be delighted to contact other collectors, both to broaden my horizons on the subject and perhaps to swap some interesting pieces. I hope, therefore, that *Eyewear* meets with success and proves to be a helpful volume for enthusiasts.

— Fritz Rathschüler

A Bit of History

A few simple enlarging instruments were known to ancient civilizations: concave mirrors that magnified the image, and convex mirrors that deformed objects, making them appear larger, smaller, elongated, or truncated to deceive or amuse the observer.

The lens, which supplanted the enlarging mirror, is a later invention. According to popular history, Nero was nearsighted and used an emerald, ground into a biconcave lens, to watch the circus at the arena; most scholars agree that the stone was not used to correct his defective eyesight, but served simply as a green filter to rest the eye, rather like sunglasses.

Before embarking on the history of spectacles, it is important 'fy the difference between spectacles and magnifying glasses. The ifying glass simply produces an enlarged image of an object. tacles, on the other hand, become a part of the eye's dioptric, or

refractive, strength, providing the necessary corrections to achieve normal vision. The object observed thus corresponds to reality.

The lens becomes an eyeglass when it has a support or frame: it is this structure that turns the history of lens making into the history of spectacles. Lenses, the functional part of spectacles, very soon became inseparably linked to the variety of devices used to hold them close to the eyes.

Documentation for the use of convex lenses to correct presbyopia, or farsightedness, dates from the late thirteenth century. The defect makes it gradually harder, more tiring, and finally impossible to focus on nearby objects, hindering reading, writing, and any activity that requires careful visual control.

A sermon by Giordano da Rivalto suggests a date for the invention of spectacles. This Dominican friar preached to the Florentines in the church of Santa Maria Novella on February 23, 1306, with a homily that included the statement that twenty years had not passed since the art of spectacle making had begun. A mention of the inventor of spectacles can also be found, in a Latin chronicle of the Dominican monastery of St. Catherine, at Pisa. The relevant passage records the funeral elegy of Alessandro Spina, a Dominican monk who died in 1313, and who had seen spectacles soon after their invention and copied them.

The geographical origin of eyeglasses is most likely Venice, the "jealous republic" that long conserved the secret of working glass and

crystal. Though the above-mentioned texts come from Florence and Pisa, other documents show that spectacles first appeared in Venice, the glass making capital of the time.

The earliest spectacle lenses were made of rock crystal or beryl, a silicate material. Texts show that in 1300, glass makers were forbidden to sell spectacles (*roidi da oglió*–"eye circles" in Venetian dialect) or magnifying glasses (*lapides ad legendum*) as crystal. A year later, the Elder Judges superintending the arts lifted this restriction, allowing anyone to make *vitreos ab oculis ad legendum,* as long as they were sold as glass and not as crystal, to avoid fraud.

Because the first spectacle lenses were made in beryl or rock crystal, they became known indeterminately as *beryls.* The word *brillen* for lenses has survived in Germany; in France, the early term *béricles* was followed by *bésicles.* The corresponding term in the Piedmont dialect of Northern Italy was, and still is, *baricole.* Nicolò Cusano (1401–1464) described the mineral as follows: "Beryl is a shining, colorless and transparent stone, which can be concavely or convexly shaped: whoever looks through them can discover things that were formerly invisible."

Spectacles should be thought of as a tool that appeared more or less contemporaneously in different locations, an instrument that served to restore normal vision when placed in front of a defective eye. The adoption of spectacles was encouraged by necessity in those activities in which defective eyesight impeded work. The earliest records of the use of spectacles come from monasteries, where, during the Middle

Ages, monks meticulously transcribed texts to preserve the historical and literary heritage of ancient civilizations.

The earliest known depiction of lenses and spectacles can be seen in two fresco panels, painted in 1352 by Tomaso da Modena in the church of San Niccolò at Treviso. The Dominican Cardinal Hugh of Provence is shown with spectacles, and Cardinal Nicolas of Rouen reads with the help of a lens. The spectacles in these early pictures appear to be made of two reading lenses, joined with a pivot placed at the ends of the handles.

The invention of printing (1450) was a great stimulus for the spread of spectacles, which accompanied widening literacy.

During the second half of the fifteenth century, glasses with biconcave lenses for correcting nearsightedness appeared. A letter dated October 21, 1462, and signed by Francesco Sforza, Duke of Milan, contains a request for three dozen pairs of spectacles from Florence: a dozen for farsightedness, a dozen for normal sight, and a dozen for nearsightedness.

The earliest spectacles were made with two lenses mounted in rims of metal or beaten leather, joined with a hinge at the ends of the handles. They were held by hand in front of the eyes to aid reading, and were not worn continuously. Later the one-piece bridge appeared, at first rigid and then made in the form of a spring that pressed the two rims to the sides of the nose. Spring-bridge spectacles anticipated the later "pince-nez" that turned out to be annoying, painful, and prone to falling off. As both hinged and spring-bridge frames were inherently

unstable, all sorts of devices were used to hold the lenses firmly in front of the eyes: one of the most original methods linked the lenses to a cord that encircled the head. Other systems included a loop that passed over the ears, and a curved vertical rod that was fixed under the hat, cap, or headband.

Stability of spectacles probably became a more important consideration when better lenses were made, more efficient in their task of rectifying the eye's dioptric strength. Scientific analysis of the eyeglass's function began in the seventeenth century, and Deca de Valdes, notary for the Holy See in Seville, Spain, has left us the practical details in his book on spectacles published in 1623, *Uso de los antojos para todo genere de vistas (Use of Eyeglasses for All Sorts of Sight)*. The author classified the strength of lenses according to the concave or convex curvature, the grade corresponding to the diameter of the sphere from which the lens was made. This scale is equivalent to today's classification in diopters.

In addition, the author made a study of the decline of eyesight with age. He advised stronger lenses for women, who, because their work involved fine, meticulous tasks, were more prone to a decrease in eyesight.

The most efficient means of holding spectacles in position appeared 350 years after their invention: the arm. Edward Scarlett, an English optician, perfected "temple spectacles" between 1723 and 1730. These glasses were fitted with rigid lateral arms terminating in wide rings that pressed against the temples.

In the same period the fashion of the lorgnette began, both in the opulent decadence of Venice and at the court of France. Glasses with a handle, they were masterpieces of jewelry in gold and precious stones. The onset of the fashion in Venice brought about the renaissance of spectacle making in the late seventeenth, and during the first half of the eighteenth century. Used by men and women alike, lorgnettes were an important part of noble dress, and were used even by those whose eyesight had no need of correction. No gentlewoman, old or young, left the house without her precious lorgnette with its long handle, and no gentleman went without the single lens mounted on a shorter rod, tied to a cord that was passed around the neck.

Later the eyepiece was suspended from a chain or ribbon; as the style developed, the narrow black ribbon was habitually fixed to the shoulder with a clasp more elaborate than that of a belt, so that the ribbon should not appear to be that normally used to hang a pair of scissors. Soon after, the lorgnette with two lenses joined by a bridge appeared. When not in use, a pivot at the bridge allowed the glasses to be folded so that the lenses were superimposed.

Bifocal spectacles were introduced between 1760 and 1784, and were also known as "double glasses," as each lens was divided into two parts. Their invention is attributed to Benjamin Franklin.

When spectacles became widely considered as being indispensable for daily work, factories sprang up in France, Spain, Holland, Germany, Czechoslovakia, England, and the United States. This competition signaled a crisis for Italian production. Italy was rich in the raw

materials used in the early years of glass making: quartz from the Ticino and from the Saravezza quarries in the province of Lucca, and potash, derived from the combustion of wood, the fundamental requirement for attaining the high temperatures necessary for melting quartz in the furnaces.

Eventually, deposits of silica were discovered and quarried in France. This substance possesses all the qualities of quartz, and furthermore does not contain those ferrous substances that render glass impure. In Italy, to obtain a satisfactory glass it was necessary to bring the quartz to red heat in the furnace and then immerse it in large basins of cold water, to make the quartz breakable. It was duly broken into minute fragments and then selected piece by piece in order to avoid the ferrous veins present in quartz. Finally the lumps were ground, sieved and made into a dust, ready to be melted in the furnace. The French quarries yielded this material naturally, purer than even the most thorough Italian procedures could make.

Extraction of siliceous sand in France cost no more than the extraction of quartz in Italy. The production of white glass, or crystal, decreased in Italy because a costly process yielded an impure material, whereas in France and Bohemia a lesser investment produced a material that was consistently more transparent and therefore more competitive. In addition, French and Bohemian glass-making industries were favored by the numerous coal mines in the region, reducing the price of fuel in comparison to wood.

Technological developments in glass making brought substantial improvements to spectacle lenses. The glass used for early lenses was the same used for other glass products. Lenses often contained imperfections and were colored as a result of impurities. During the last twenty years of the eighteenth century, Pierre Louis Guinard discovered that mixing molten glass improved its homogeneity.

Frames also progressed. Tortoiseshell was very popular for spectacles with arms, but this and another prized material, ivory, became rare, encouraging the search for other materials besides metal that would satisfy market demand. When celluloid and plastics were invented and became widely used, the classic gold, silver, tortoiseshell, and ivory were still employed for luxury frames.

In the nineteenth century, Alexander Partes, from Birmingham, England, carried out a series of experiments that led to the creation of celluloid. Other researchers in America attempted to produce a plastic with the properties of celluloid in the early 1870s. Factories opened in France (1875), England (1878), Germany (1878), Japan (1900), and Italy (1924). The procedure for making celluloid spectacle frames was patented in 1879 by the American J. Spencer.

Between 1800 and 1870 in Italy there was no industrial production of spectacles. Traveling salesmen and opticians sold foreign-made spectacles and trinkets as well as glasses, imported particularly from France and Germany. One of these numerous traveling salesmen was Angelo Frescura, who eventually conceived, managed, and financed the

first modern Italian spectacles factory, in his home region of Cadore in 1877. Lenses and frames were imported from France; the factory ground the edges of the lenses, and mounted them in rimmed and rimless frames. As well as making spectacles, the firm produced folding rulers, in great demand at the time. The earliest Italian celluloid spectacles frame was made in 1910 by Larese of Naples, optician, haberdasher, and knife-grinder. After the outbreak of the World War I, the processing of celluloid that had just begun in Cadore was suppressed, and recommenced only in 1920. This marked the beginning of the extensive Italian manufacture of celluloid spectacle frames, which was to become highly specialized.

BIBLIOGRAPHY

Albertotti, G. "Lettera intorno all invenzione degli occhiali all'onorevolissimo Senatore Isodoro il Lungo, in occasione del VII Centenario della Real Università di Padova," in *Annali d'Oftalmologia e clinica oculistica*: L. fasc. 1, 2, 1922.

Bavati, G. Catalogo "La lente, storia, scienza, curiosità attraverso le collezioni di Fritz Rathschüler," *Ecig Genova*, 1988, p. 198.

Bordoni, E. *L'industria del vetro in Italia*, Tip. A. Ricci, Savona.

De Lotto, E. *Dallo smeraldo di Nerone agli occhiali di Cadore*, Trescore (BG) 1966.

Illardi, V. *Occhiali di Francesco e Galeazzo Maria Sforza con documenti inediti del 1402-1466*, Metal Lux S.p.A., Milano, 1966, p. 16.

Letocha, C. *The Origin of Spectacles—Survey of Ophthalmology*, vol. 31: 1986, pp. 185–188.

Marly, P. *Les lunettes*, Paris, 1980, p. 31.

Nanni, D. M. *Degli occhiali da naso inventati da Salvino Armati Gentiluomo Fiorentino*, A.M. Albizzi, Firenze, 1738.

Pensier, P. *Histoire des lunettes*, Paris, 1901, p. 137.

Ronchi, V. *Occhi e occhiali*, Bologna, 1948.

Rosen, V. "The Invention of Eyeglasses," *J. Hist. Med. Alliad Sci. II*, 1956, pp. 13–46, 183–218.

Zecchin, L. "I 'cristallier' e l'invenzione degli occhiali," in *Giornale Economico della Camera di commercio di Venezia*, 1956, pp. 832–837.

Bella Cosa